To The Howes,
Thank you very much for having us.

Susie & Terry Cotton
Suzie & Charlie Boyle.

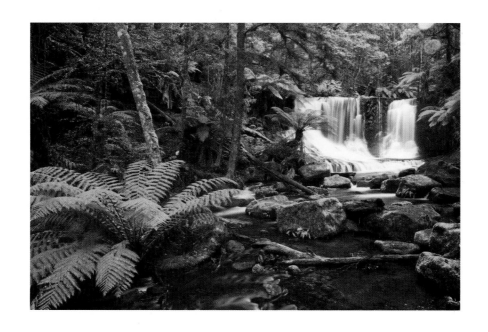

LANDSCAPES OF AUSTRALIA

PHOTOGRAPHS FROM THE AUSTRALIAN GEOGRAPHIC IMAGE COLLECTION

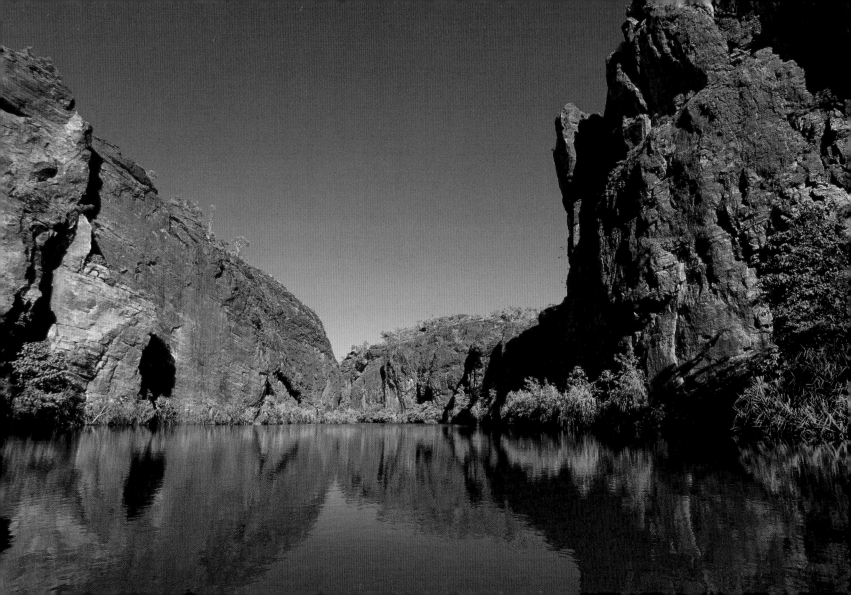

CONTENTS

OPPOSITE: *Middle Gorge, Boodjamulla (Lawn Hill) National Park, Qld.* MURRAY SPENCE

Popular with kayakers, Lawn Hill Creek's emerald waters flow through Middle Gorge.
Red cliffs tower overhead and livistona palms line the banks.

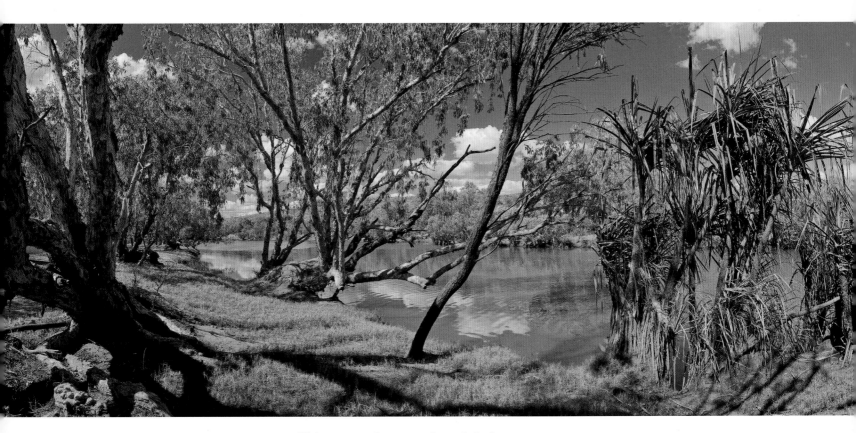

Billabong, Mornington station, Kimberley, WA. NICK RAINS
Lush silver cadjeput, wingnut trees and pandanus line the banks of a Kimberley
waterhole providing vital dry-season habitat for many native species.

INTRODUCTION

Most Australians live among the bright lights of the city, but it is the twinkling stars and stunning scenery that we crave. From moist rainforests to arid desert dunes, we want to explore it all.

AUSTRALIA has its share of bright lights and high-rises, but the places locals dream about are mostly elsewhere. It could be a shack on the coast or a spot in the mountains. It might simply be the idea of going bush and finding a track to follow. These dreams thrive because there are places aplenty. The only border we know is 36,000km of coastline. And the 80 per cent of the continent where most of us don't live is tantalising terrain — hauntingly vast and chock-full of surprises.

It's as diverse a mix as can be imagined, from limpid tropical rainforests to coastlines battered by the Roaring Forties. In between there are deserts and outback ranges, remnant volcanoes, sand islands, expansive woodlands and some of the world's most remarkable gorges. Moreover, the weathered antiquity of the continent has fashioned an incredible spread of micro-habitats. Plants and other life have adapted with subtle and myriad variations to the land's often meagre resources. Whatever the season, there's always a place to aim for, a new corner to explore.

For Australians, the power of landscape, in all its physicality and episodic unrest, is never far away. Our largest capital perches on the edge of a dramatic harbour cradled within a much larger fortress of sandstone and bush. In fact all our cities have a raw outer edge; a feeling of wildness on the doorstep. And no town or CBD is ever entirely cut off from natural events, be it a dust storm, a cyclone, a wildfire or a surging flood.

Being bound to this reality has, in turn, prodded us into exploring the country's wilder outposts. A newfound mobility has ushered in a modern era of bush travel. Along the way Australia's landscapes have become as celebrated and fabled as any castle or set of ancient ruins. Nevertheless, mysteries remain. Such is the sheer scale of the country, and the confronting terrain, that it will always hold the promise of stories — old and new — still to be discovered.

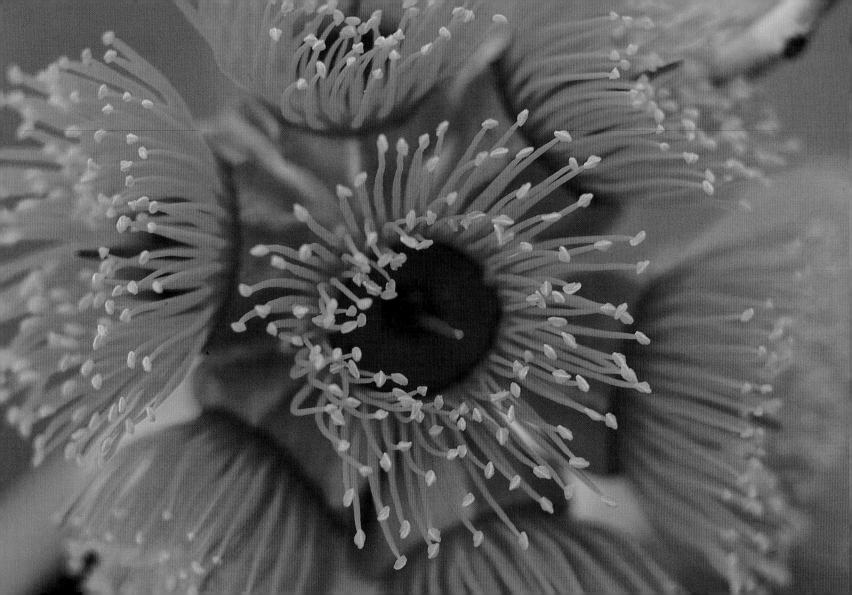

BUSH

We are girt by sea, but it is the iconic Australian bush — tall gum trees, wheeling birds and still billabongs — that has captured our hearts.

FOR AUSTRALIANS, "bush" conjures rich associations. It's a catch-all description for a sprawl of habitats inland of the coast, yet stopping short of the arid outback. Typically it includes mixed country with patches of scrub, farmland and a smattering of tall timber.

In the local lingo 'going bush' suggests a cast of mind, an urge to cut loose from city ties and live close to the land. By association, a 'bushie' is a carefree spirit, resourceful, a little defiant and yet loyal to the traditions of place. For some, a house in a small country town or a block with a few trees on the suburban fringe is bush enough. To others you're not a real bushie unless the sights and sounds of nature exclude all others.

Prime bush strongholds include woodland habitats west of the Great Divide, the mallee country of SA, Queensland's Brigalow Belt and the diverse plant communities of south-west WA.

In truth, however, the bush can be almost anywhere on the continent, especially if there's the shade of a few big gums, some birds on the wing and water nearby. Thus the essence of the bush endures as an affectionate ideal. It's layered with allusions to song and poetry, long-lost forebears and the ever-present dreams of escape to a better life.

OPPOSITE: ***Woollybutt, Nitmiluk National Park, NT.*** NICK RAINS

Also known as the yiwal by the local Jawoyn people, this brightly hued bloom is one of more than 740 plant species recorded in Nitmiluk (Katherine Gorge) National Park.

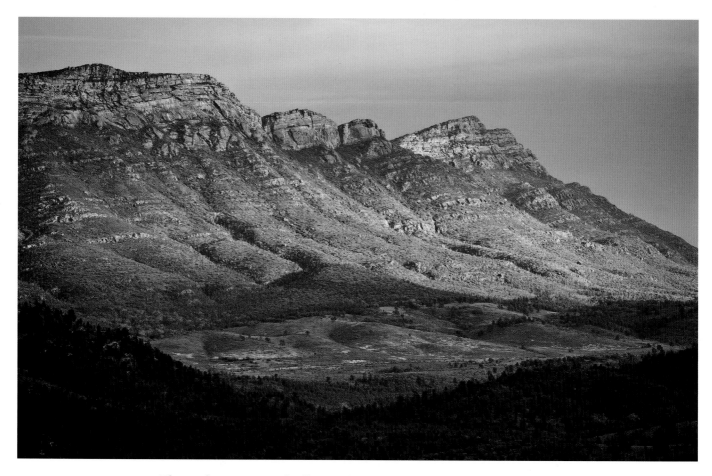

The south-east corner of Wilpena Pound, Flinders Ranges, SA. MIKE LANGFORD

The imposing, saw-toothed ramparts of Wilpena Pound (Ikara) are sacred to the local
Adnyamathanha people and one of the Flinders Ranges' chief drawcards.

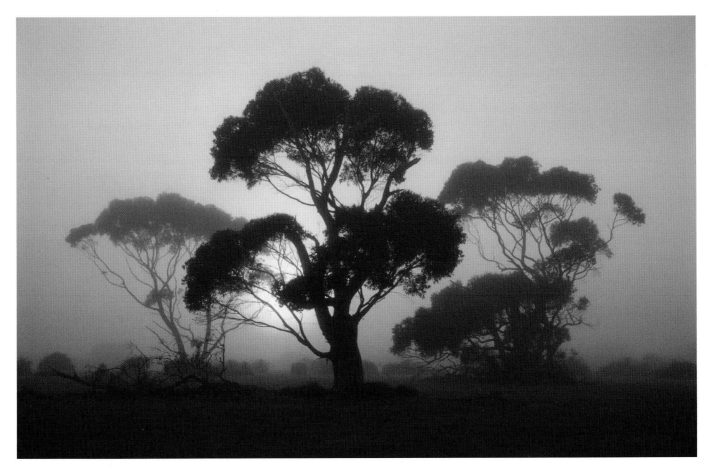

Sugar gums, Grassdale, Kangaroo Island, SA. COLIN BEARD

A paradise for birdwatchers, Grassdale, at the western end of the island, boasts two lagoons,
a river and a woodland that provide a haven for more than 200 bird species.

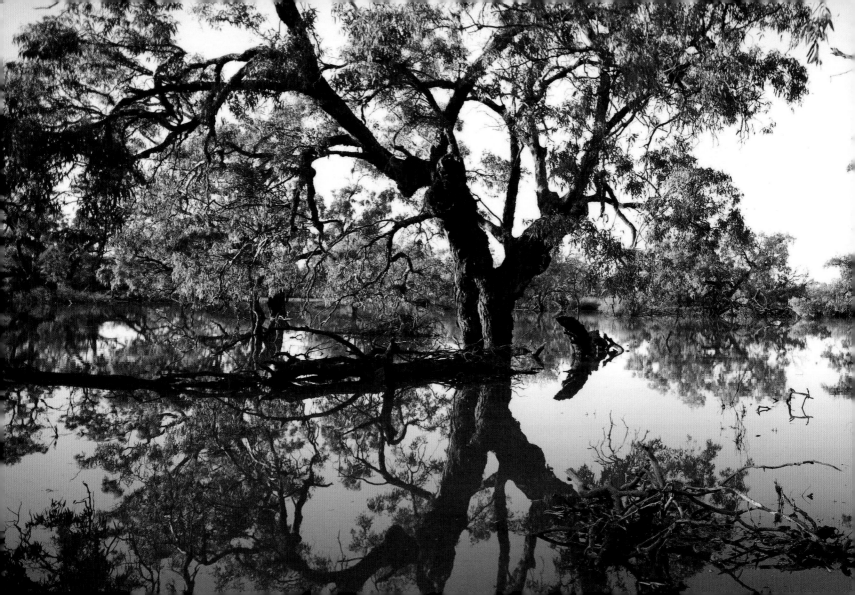

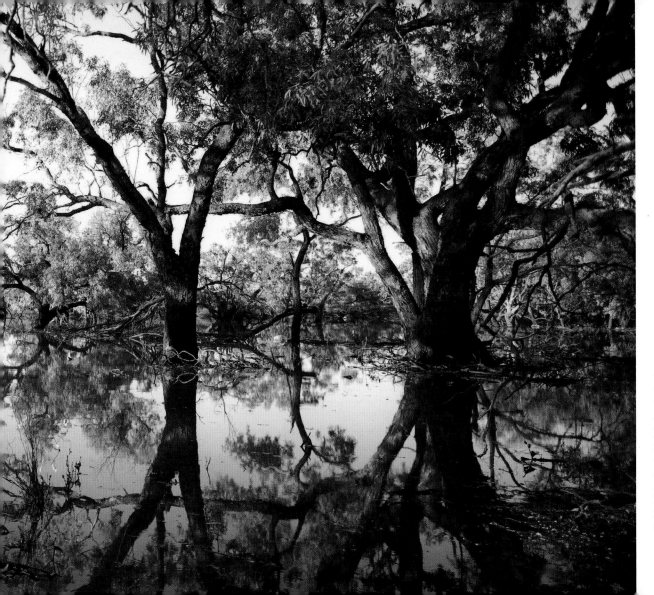

River red gums along Cuttaburra Creek, NSW.

ANDREW GREGORY

Fed by heavy rains in southern Queensland, the ephemeral wetlands of the Cuttaburra Basin enjoyed once-in-a-generation floods in 2008.

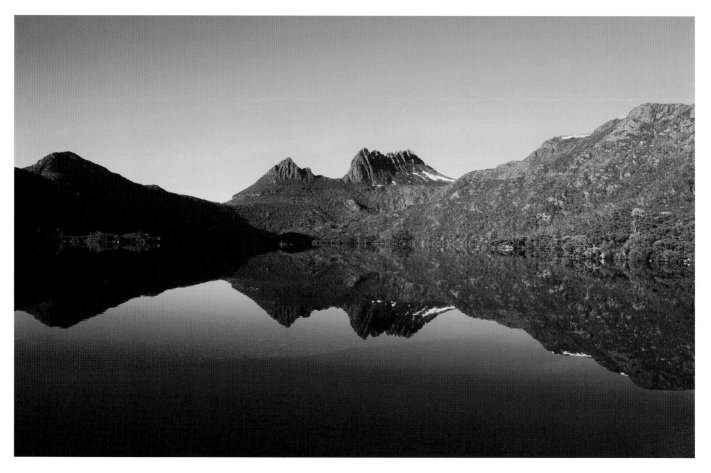

Cradle Mountain, Cradle Mountain–Lake St Clair National Park, Tas. JASON EDWARDS

The jagged backbone of this iconic mountain is reflected in the still, chill waters
of Lake Hanson in Tassie's World Heritage-listed wilderness region.

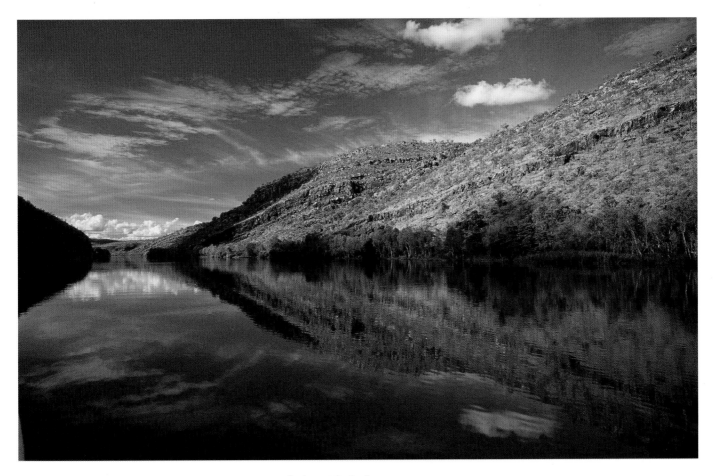

Ord River, Kimberley, WA. NICK RAINS

The Ord's annual floods were harnessed for agriculture by two dams built between 1960 and 1971, creating 980sq.km Lake Argyle that can double in size during the Wet.

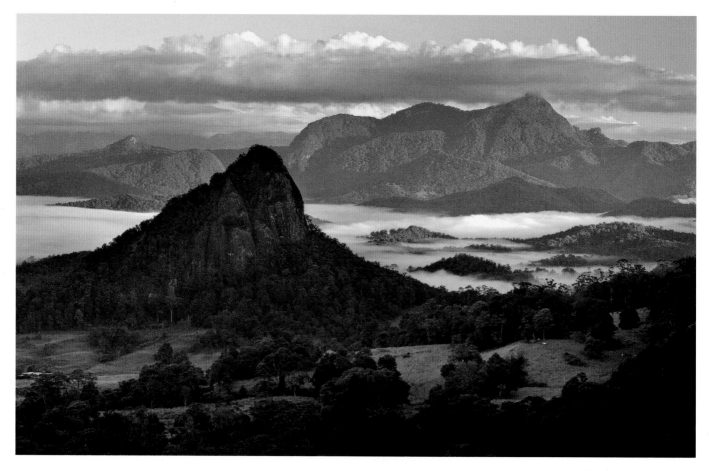

Mt Warning, Gondwana Rainforests, NSW. NICK RAINS

Known as Wollumbin (cloud catcher) to the local Bundjalung people, this 1156m
volcanic plug is part of the caldera rim surrounding the Tweed Valley.

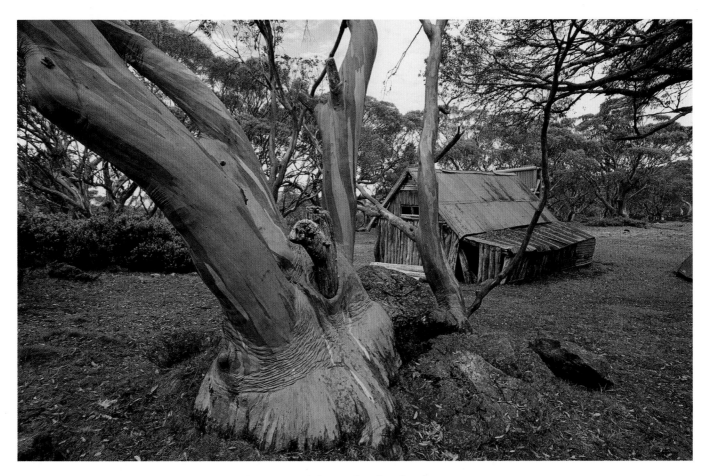

Wallaces Hut, Alpine National Park, Vic. DON FUCHS

Built in 1889, this hut is the oldest complete structure in the national park. Early bushwalkers, taken with its beauty and isolation, nicknamed it the 'Seldom Seen Inn'.

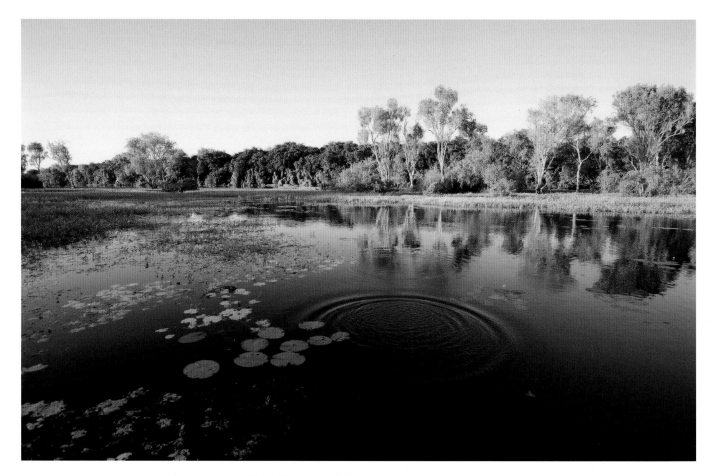

McCreadies Billabong, Labelle Downs station, NT. NICK RAINS

Tropical billabongs can fluctuate greatly with the seasons. The word 'billabong'
has Wiradjuri origins meaning 'a watercourse that runs only after rain'.

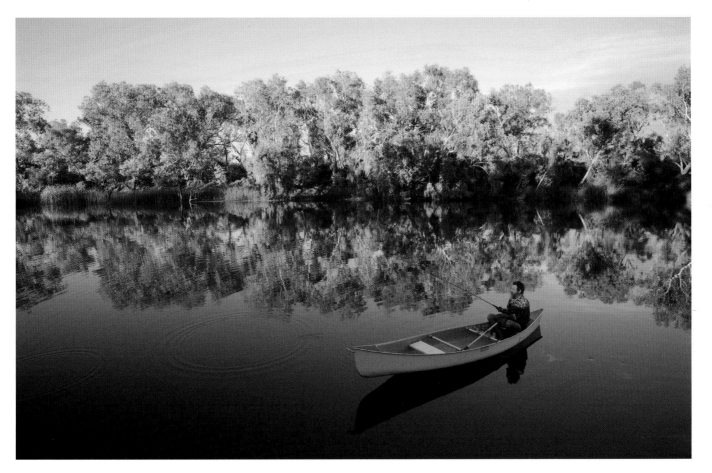

Crossing Pool (Murlamunyjunha), Millstream Chichester National Park, WA. NICK RAINS

Barely a ripple disturbs an angler's early morning on one of Millstream's numerous permanent freshwater pools fed by a 2000sq.km underground aquifer.

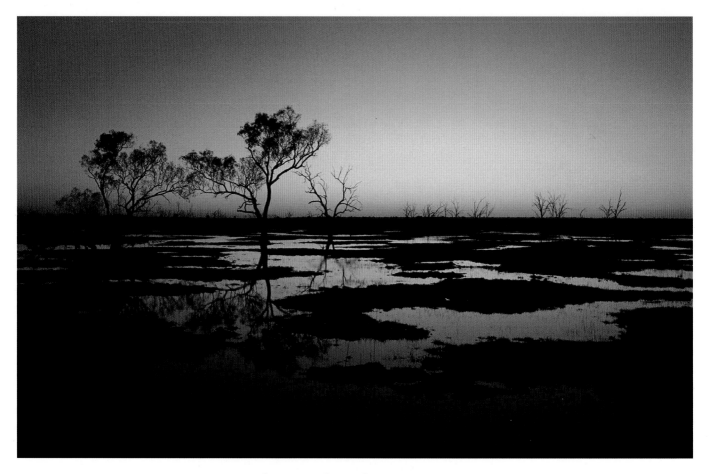

Dawn on the Macquarie Marshes, NSW. GRENVILLE TURNER

A mosaic of waterways, grasslands and aquatic vegetation, the marshes are a 2000sq.km
wetland and one of Australia's most important waterbird breeding sites.

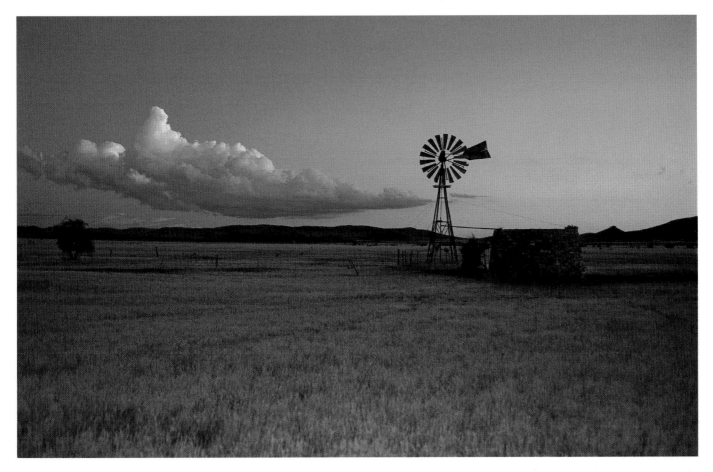

Wonoka Plain, Hawker, Flinders Ranges, SA. MIKE LANGFORD

The farming push of the 1870s saw many small farms built across the harsh, dry expanse
of the southern Flinders. Many failed and their ruins dot the rolling plains.

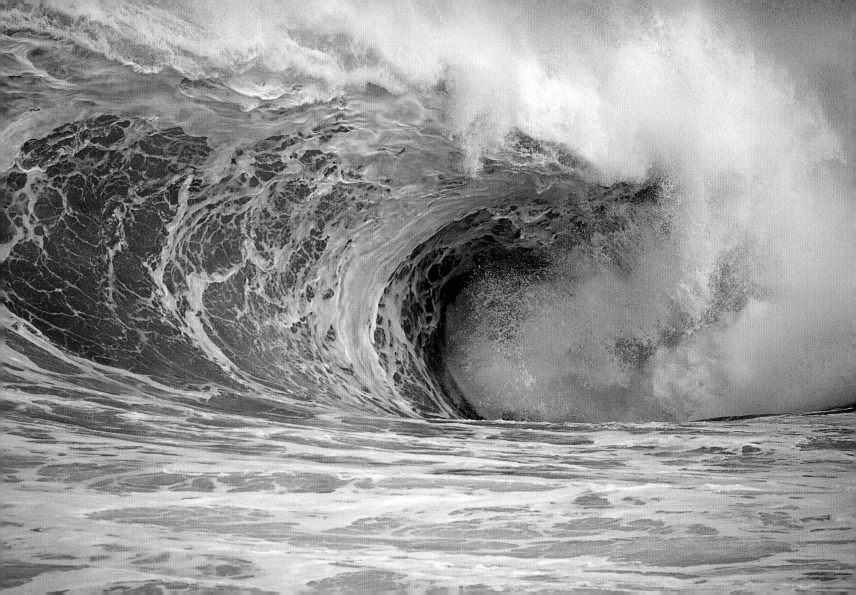

COAST

The sound of crashing waves, the taste of salt spray in the air and the sight of a brilliant stretch of golden sand lures us to Australia's coastline.

BOUNDED by three of the world's oceans and four seas, our coast offers an array of natural treasures. For each sheltered bay, there're a hundred more headlands, stretches of mangrove flat and ragged cliff.

These frontiers are as unruly as any on earth. Some of the country's most outlandish refuges hug the shore, including the Tarkine and the Daintree, the Coburg Peninsula, the Coorong and Cape Arid. From another angle, Australia's mainland can be considered the largest isle in an 8000-strong archipelago. From Bass Strait to Torres Strait, and the Great Barrier Reef islands to the scores lurking off the Kimberley coast, our near waters are dotted with outliers.

Construed in this entirety the coast swamps the imagination. All those twists and turns. So much fury of wind and wave. Not to mention a startling inventory of hazards: rip currents, crocodiles, sharks and assorted stingers.

Yet Aussies have a knack of taking all this in their easy-going stride. To us the coast is a calling and a way of life rather than mere topography. For devotees, just the mention of names like Bells, Cottesloe, Byron, Noosa and Whitehaven is enough to set the heart pumping. With a powerful undertow of shared memories, such places are synonymous with family holidays, rites of passage and the irresistible allure of sand and surf.

OPPOSITE: ***Ocean off Conto Beach, Capes region, WA.*** ANDREW GREGORY

A roaring 3m swell pounds a stretch of coastline near Conto in Leeuwin–Naturaliste National Park. The area's legendary waves attract surfers from around the world.

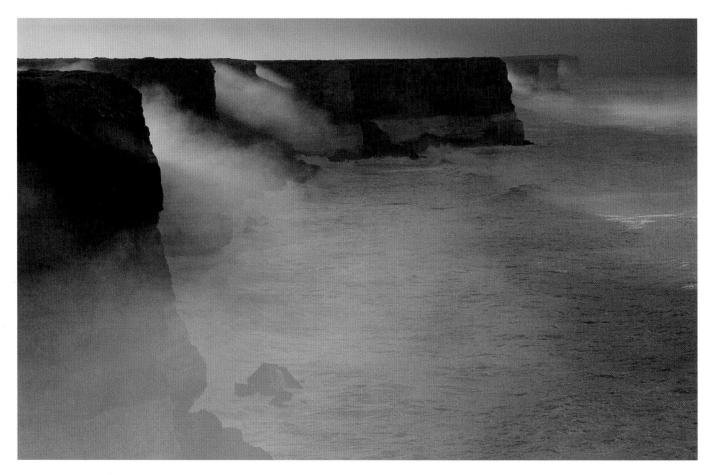

Bunda Cliffs, Nullarbor National Park, SA. MITCH REARDON

The early morning sun pierces the salt mist shrouding this 80m high rampart.
The whitish base layer was formed 45–35 million years ago.

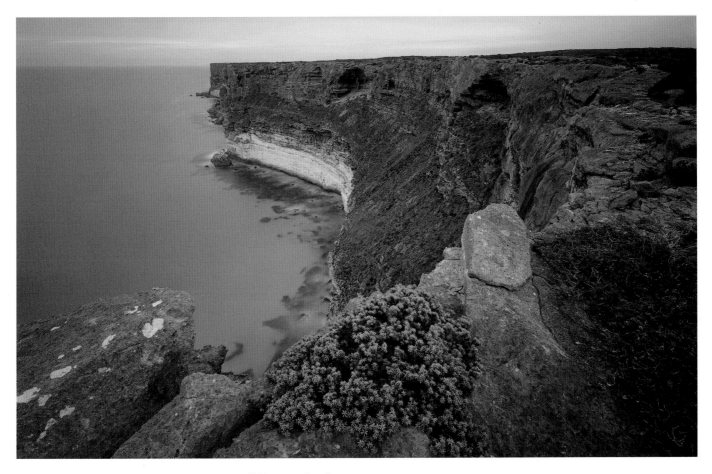

Baxter Cliffs, Nuytsland Nature Reserve, WA. ANDREW GREGORY

The huge cliffs of the Great Australian Bight, including Bunda and Baxter, extend for
790km along this windswept, remote coastline that edges the Nullarbor Plain.

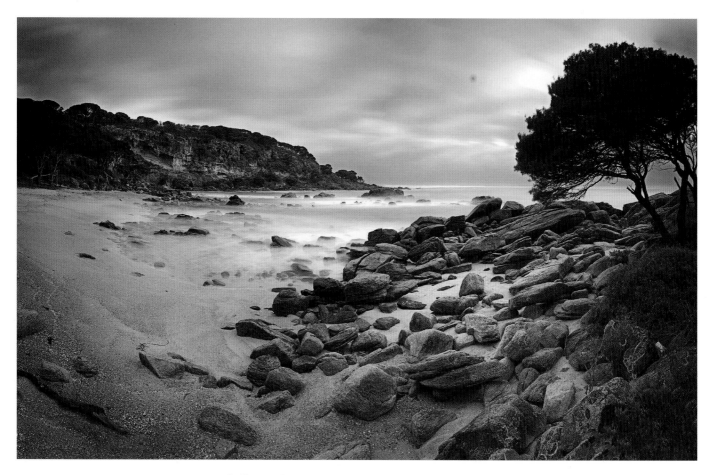

Shelly Beach, Cape Naturaliste, WA. ANDREW GREGORY

Limestone bluffs pockmarked with caves line much of the headland overlooking Shelly Beach,
which lies close to the northern end of the famous Cape to Cape Track.

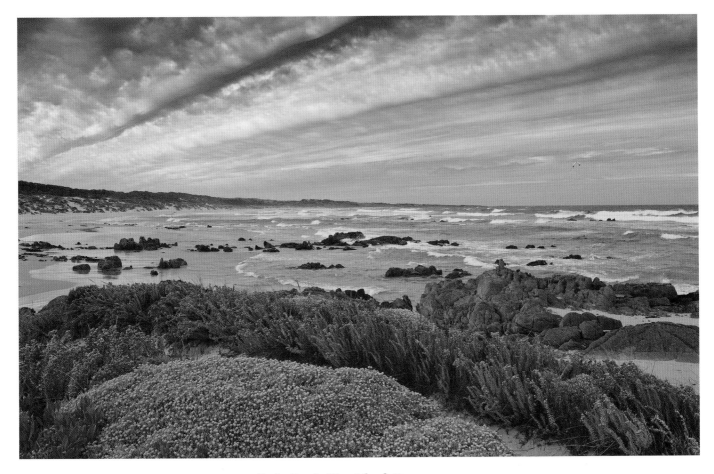

Porky Beach, King Island, Tas. BILL BACHMAN

A lone kite surfer rides the shallows on the island's west coast beneath an approaching
cold front that heralds the blustery onset of the Roaring Forties.

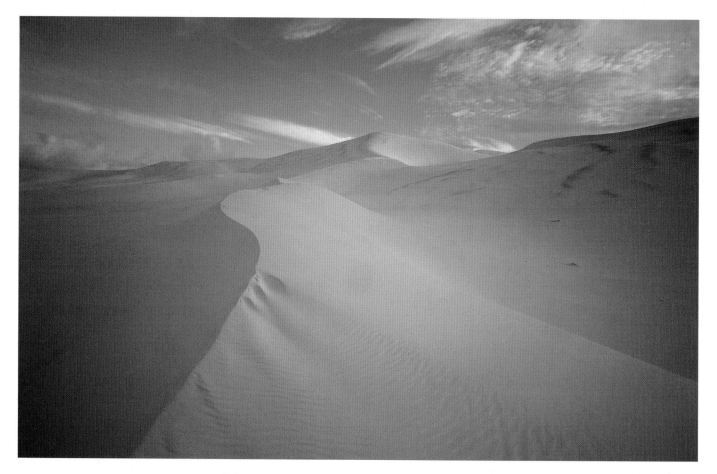

Sand dunes, Nuytsland Nature Reserve, WA. ANDREW GREGORY

Strond winds blowing off the Bight, and a steady sand supply encourage these huge
white dunes to gradually grow and move, engulfing everything in their path.

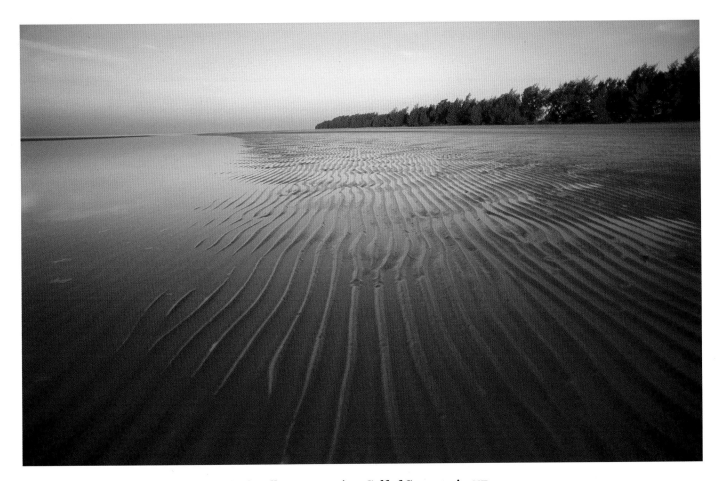

Beach north of Wollogorang station, Gulf of Carpentaria, NT. MURRAY SPENCE

Dusk paints pastels on a rippled beach 80km north of Wollogorang station where
visitors can camp under beachside casuarinas and feast on plentiful mud crabs.

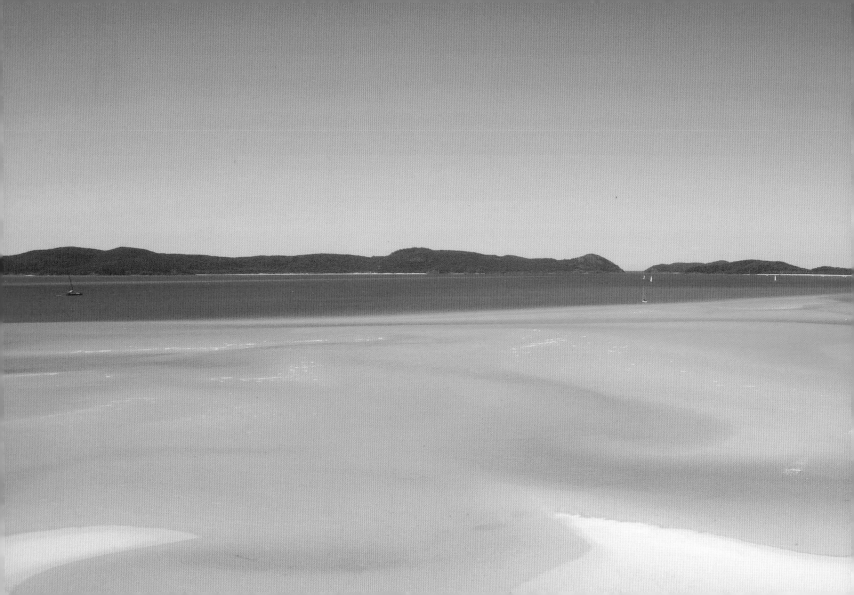

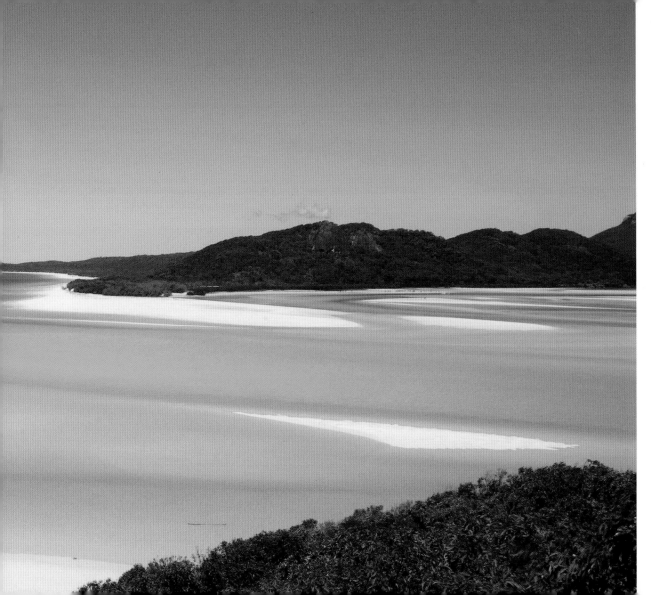

***Whitehaven Beach,
Whitsunday Island
Group, Qld.***

ANDREW GREGORY

Picture-perfect
Whitehaven boasts
5km of pristine
white silica-rich
sand and is popular
with day-trippers
from nearby
Hamilton Island.

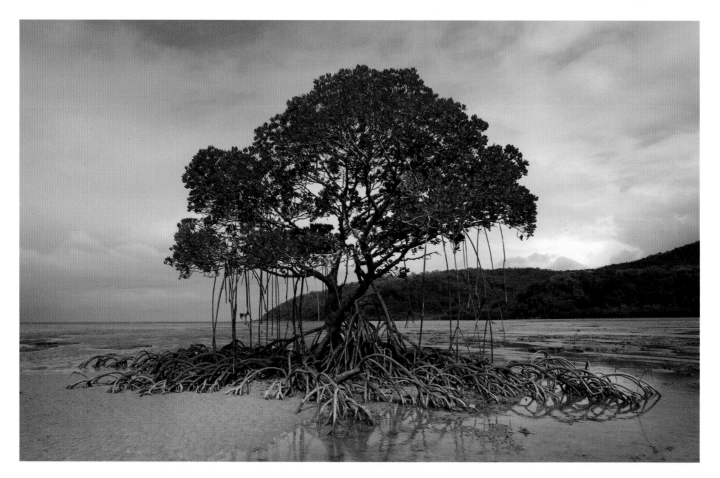

Red mangrove, Cowie Beach, Daintree National Park, Qld. ANDREW GREGORY

The tangled prop roots of this tree filter out salt to prevent its absorption and also
trap silt to build a more favourable environment for other mangroves.

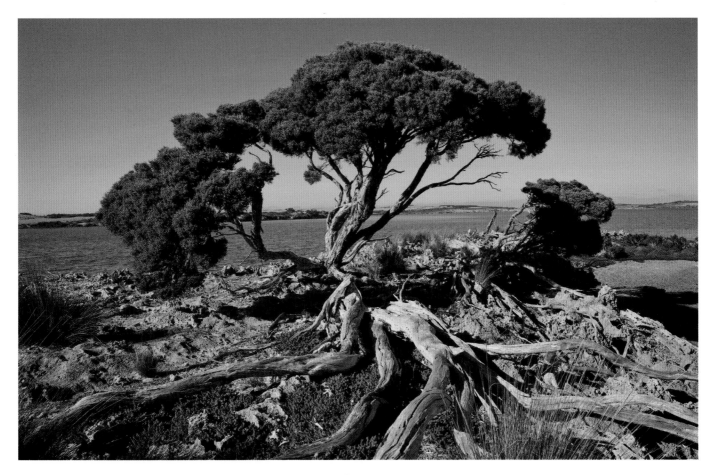

Melaleucas on Shellgrit Beach, Pelican Lagoon Conservation Park, Kangaroo Island, SA. BILL BACHMAN

With 540km of coastline, Kangaroo Island is Australia's third-largest island and Pelican Lagoon
area is a popular spot for watching and photographing waterbirds.

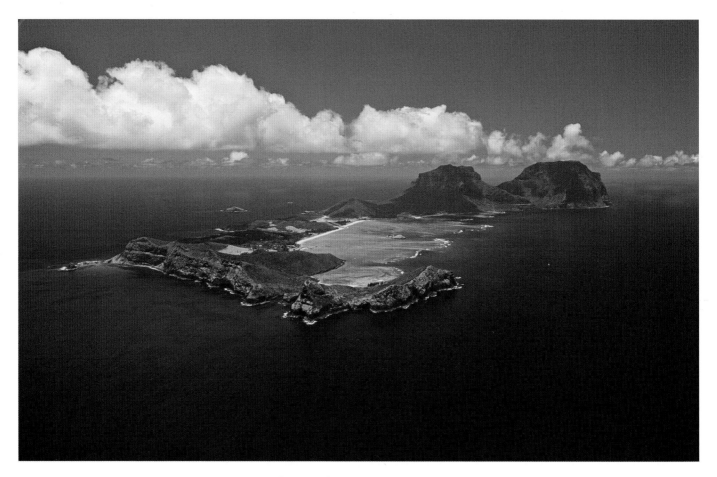

Lord Howe Island, NSW. MIKE LANGFORD

The World Heritage-listed island's 1455ha of sheer beauty inspires all who approach by air.
About 75 per cent of Lord Howe and its islets is national park.

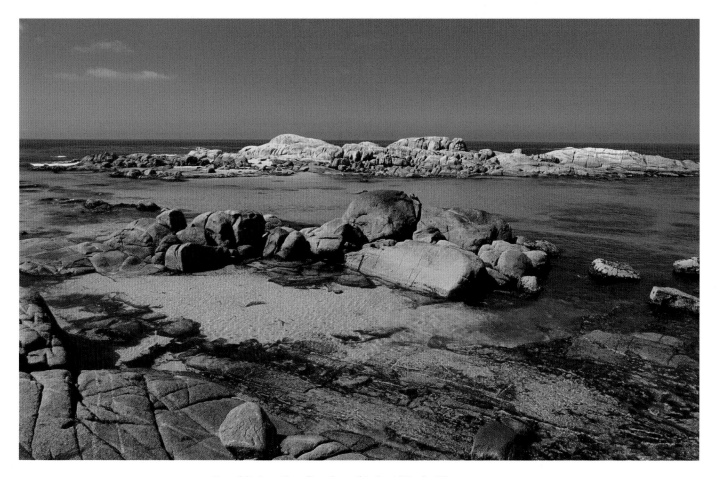

Petrel Point, Croajingolong National Park, Vic. DON FUCHS

The crystal clear, emerald waters of Petrel Point's lagoons attract visitors seeking solitude and adventure along this remote and pristine stretch of coastline accessible only by bush track or sea.

DESERT

The wide expanse of Australia's beating red heart is the last frontier, and those who venture into it are rewarded with soul-nourishing silence.

THEY'RE the monarchs among Australia's landscapes. The biggest — the Great Victoria Desert — is one and a half times the size of Great Britain. Together with the semi-arid regions, deserts occupy a staggering 70 per cent of the continent. Remote, little known and rarely visited, they are among the most defiant wilderness realms imaginable.

Far from being barren or monotonous, our deserts reveal many moods and facets. Most are a blend of grass plains, undulating sandhills, saltflats and craggy outcrops. The famed Simpson Desert is home to the world's longest parallel dune ridges, some cresting to 40m high. By contrast, the Sturt Stony Desert next door is an extraordinary constellation of flat-lying gibber plains.

While a pitifully low annual rainfall is the norm, every few years erratic summer rain events and inundating floodwaters see these expanses burst into life. Such transformations underscore the hidden power of the inland to rejuvenate itself and offer clues as to how even the most austere terrain has been occupied and traversed by Aboriginal people for tens of thousands of years.

With the advent of four-wheel-drives, desert exploration is alive again. It remains the ultimate overland adventure. And no-one who lingers through a soft desert evening ever forgets the delicate details or the silence of its spaces.

OPPOSITE: **Sand dune, Broken Hill, NSW.** THOMAS WIELECKI

Sand is a superb insulator, providing a stable, humid environment under an often roasting and unforgiving veneer, concealing myriad life just beneath the surface.

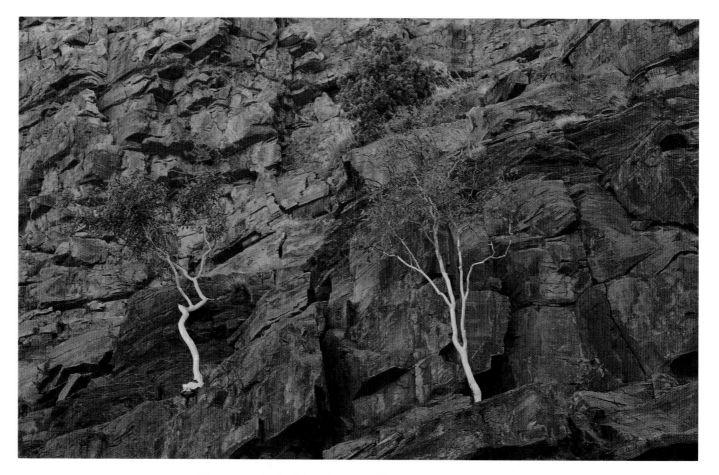

Ghost gums in the West MacDonnell Ranges, NT. BARRY SKIPSEY

The characteristic orange cliffs and ghost gums of the 'West Macs' were immortalised
by Aboriginal artist Albert Namatjira, who grew up in nearby Hermannsburg.

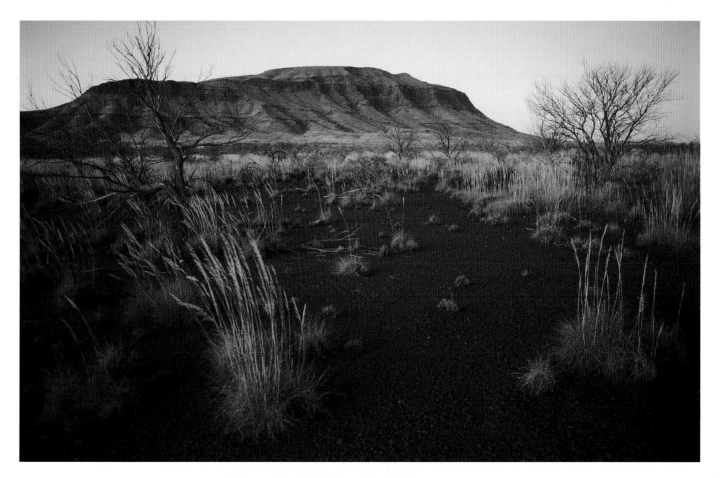

Mt Bruce, Karijini National Park, WA. DAVID DARE PARKER

This ancient landscape wears the scars of geological change. Its iron-rich rocks began
forming 2.5 billion years ago when the area lay beneath an inland sea.

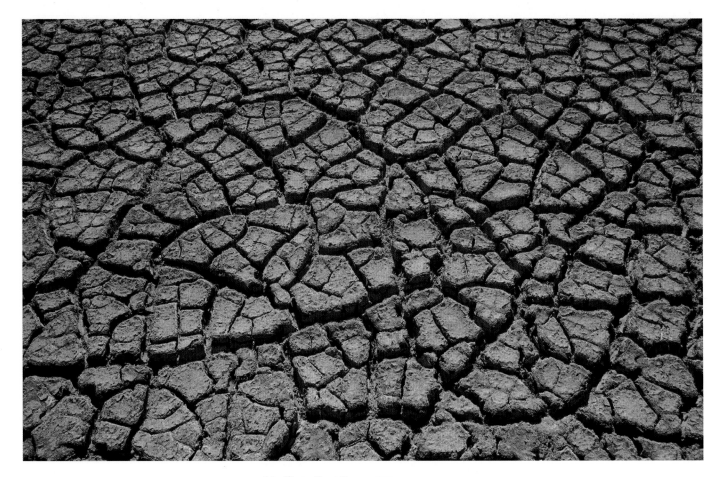

Mudflats, Port Roper, NT. BILL BACHMAN

The dry season turns the last 40km of the Roper River's floodplain into a series of rich
mudflats that support a variety of wildlife, including pelicans and saltwater crocodiles.

Aerial of Tandou Lake, Willandra Lakes area, NSW. LORRIE GRAHAM

In 1967, the deep cracking, grey clay soils of the 17,000ha dry bed of Tandou Lake
revealed an early human skull dating from the Pleistocene era.

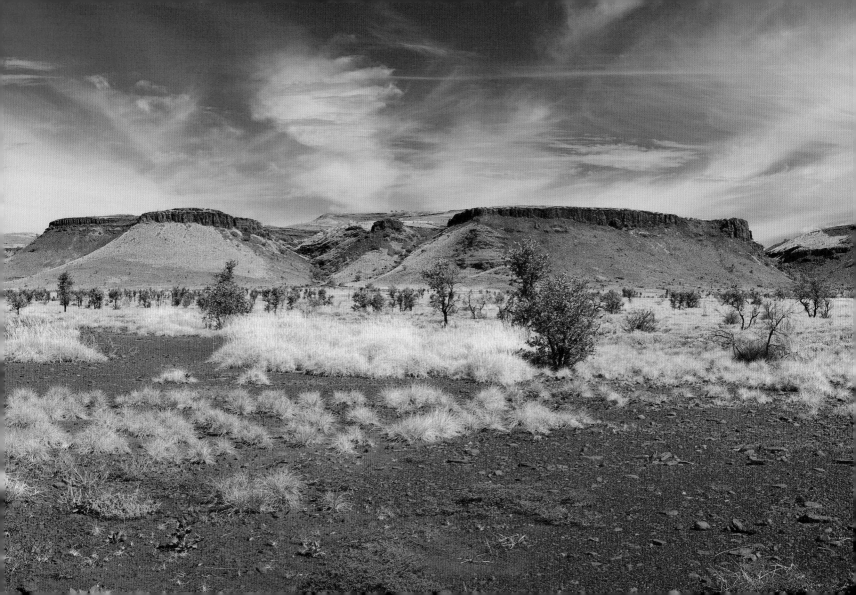

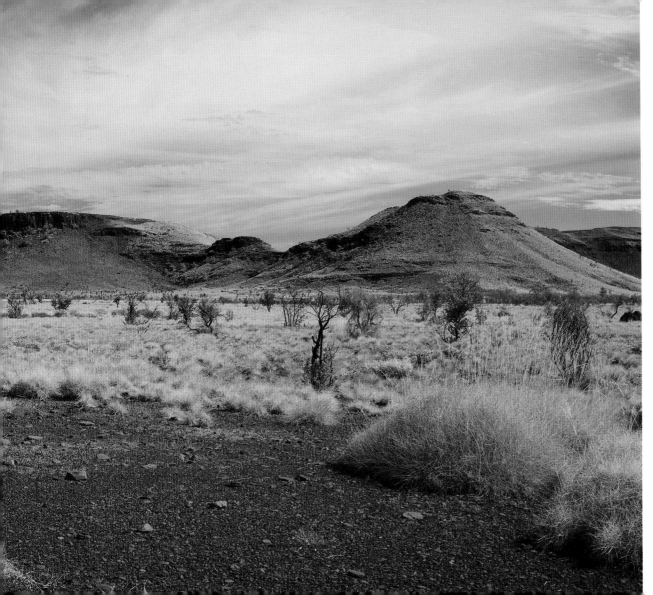

Millstream Chichester National Park, WA.

NICK RAINS

The arid tablelands dotted with spinifex grass in the George River region of this park contrast with lush, green gorges further south.

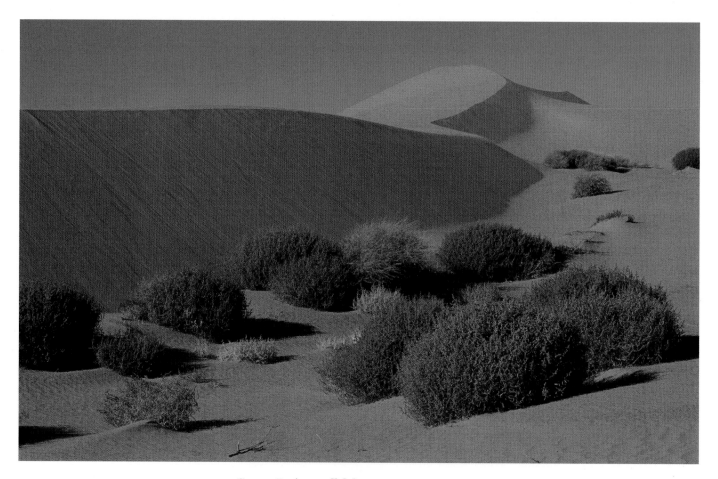

Cooper Basin parallel dunes, SA. MITCH REARDON

Dunes out here can be white, yellow or red. Dunes furthest from their source
become redder as the iron within each grain of sand slowly oxidises.

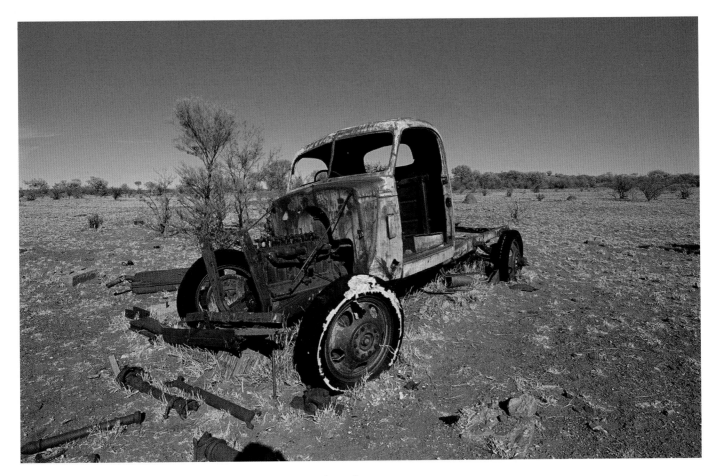

Tanami Road, NT. BILL BACHMAN

A 1940s truck slowly rusts beside the iconic 1040km Tanami Road, or track as it's better
known, that runs between Alice Springs in the NT and Halls Creek in WA.

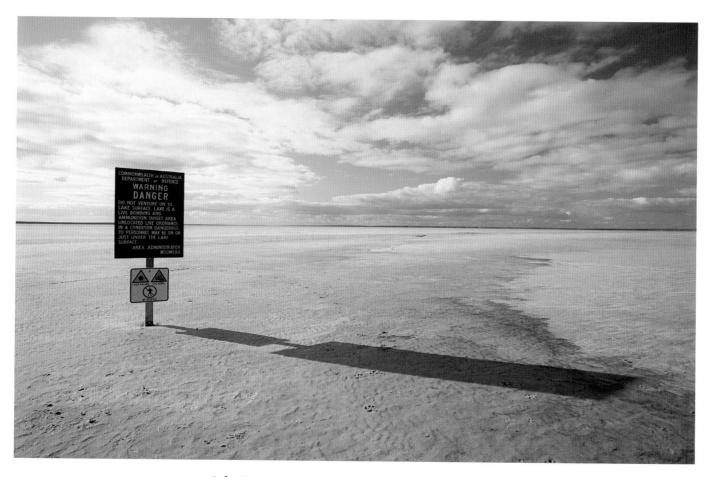

Lake Hart, Woomera Prohibited Area, SA. BARRY SKIPSEY

Unexploded bombs, rocket parts and other potentially dangerous junk
litter this area. It is still used for military testing today.

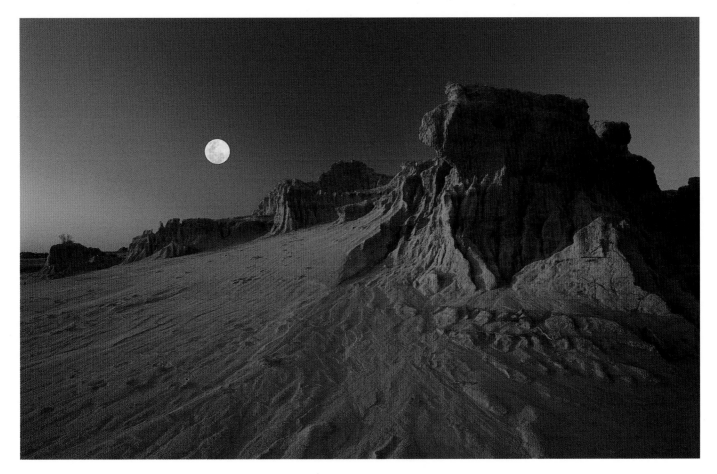

Walls of China, Mungo National Park, NSW. BARRY SKIPSEY

This ancient dune marks the relict eastern shore of a once-bountiful body of fresh water
and its sediments have yielded evidence of early human occupation.

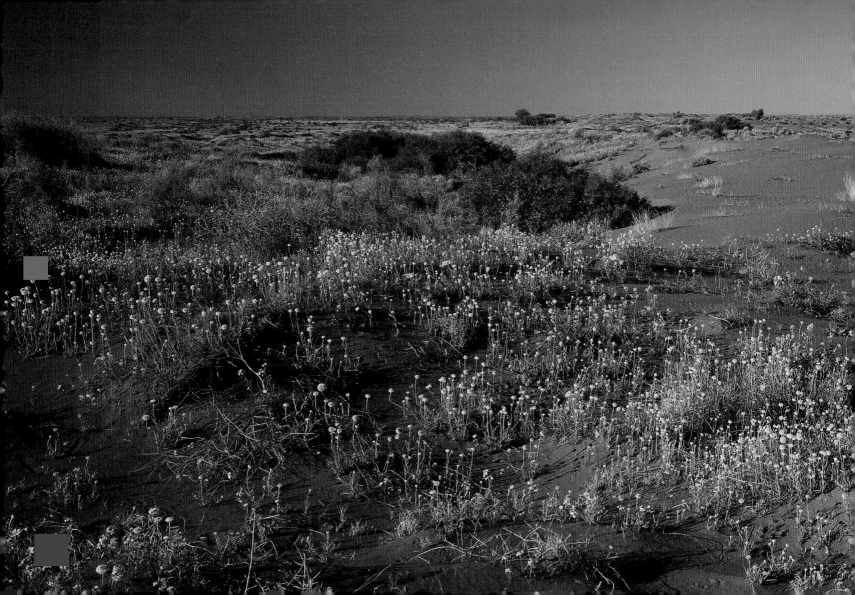

Strzelecki Desert, SA.

BILL BACHMAN

Fleshy groundsel and yellow-tops enliven a red sand dune near Merty Merty station in the Innamincka Regional Reserve.

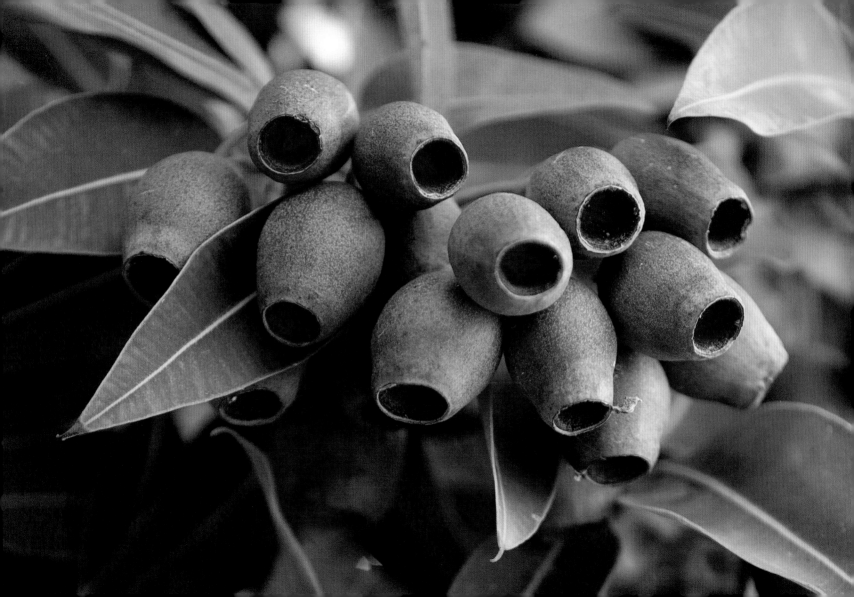

FOREST

From tall stands of iconic eucalypts to the moist tropical rainforests of the north, Australia's forests are a refuge and a nod to our ancient past.

DESPITE a fickle climate and poor soils, Australia still boasts the sixth-largest forest area in the world — mostly thanks to the triumph of the eucalypts. Their 900 species are the legacy of a remarkable evolutionary journey aboard an increasingly arid and fire-prone continent.

Covering some 116 million hectares, eucalypt forests do much more than adorn the landscape. They're an eternal presence whose speckled shadows and oily scent fuel our deepest feelings of belonging. Included in their number are giants like the omnipresent river red gum, the karri and jarrah forests of the south-west and the mountain ash — the world's tallest flowering plant, capable of soaring skyward for more than 100m.

Many other forest species have joined the struggle for survival across Australia's dry interior, including a huge array of acacias, several species of stately callitris and no fewer than 66 species of casuarina. Given the rigours of the inland it seems incomprehensible to us today that the entire continent was once blanketed with lush rainforest.

Thankfully, vestiges of these forests endure as testimony to this ancestral past. To bear witness to the clutches of moss-draped antarctic beech in far northern NSW or stand beneath Tasmania's wondrous stands of gnarled myrtle beech and celery-top pine is to glimpse a kind of miracle, a vision of the way our world appeared 60 million years ago.

OPPOSITE: **Western Australian flowering gum.** BILL BACHMAN

Superbly adapted and doggedly resilient, more than 900 eucalypt species occur right across Australia in every kind of landscape and climate.

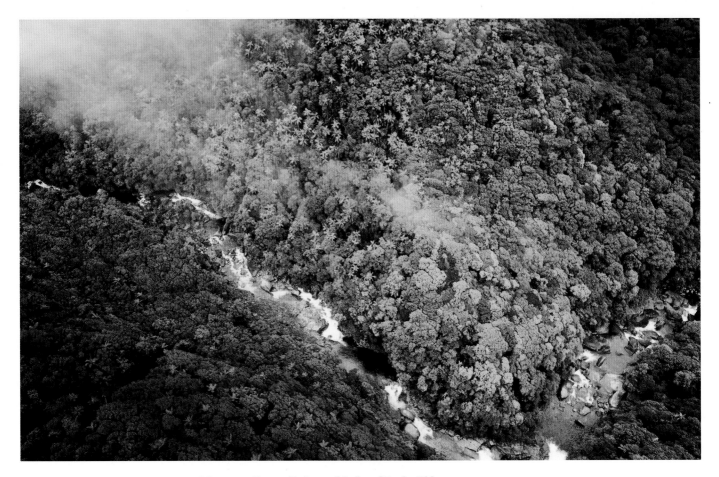

Mossman Gorge, Daintree National Park, Qld. ANDREW GREGORY

Steep terrain and dense tropical rainforest vegetation restrict visitors to only some
parts of Mossman Gorge in one of the world's most biodiverse regions.

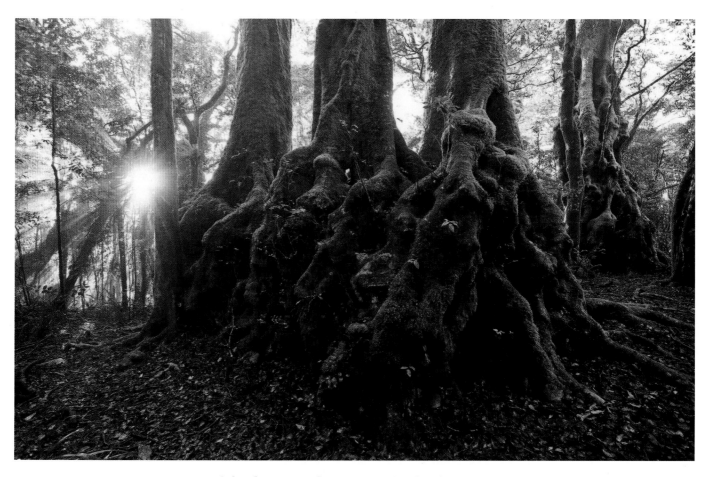

Antarctic beech trees, Border Ranges National Park, NSW. NICK RAINS

In the early morning mist, these giants cling to the extinct Tweed volcano's rim. They help support the greatest concentrations of marsupial, frog and bird species in Australia.

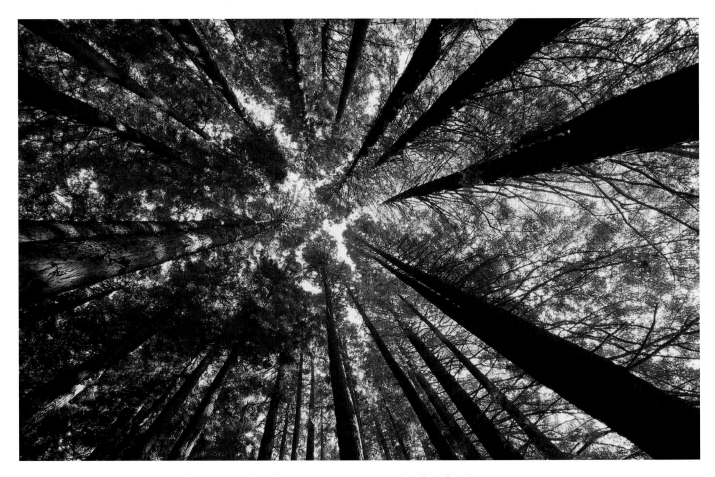

Californian redwood trees, Great Otway National Park, Vic. MIKE LEONARD
A grand stand of Californian redwoods can be found near Hopetoun Falls close to the
Great Ocean Road. They were planted in 1938 as part of a forestry experiment.

River pandanus, NT. BILL BACHMAN

This Top End tree is the smallest of Australia's pandanus species, reaching up
to 5m in height. It is found growing along river banks in tropical zones.

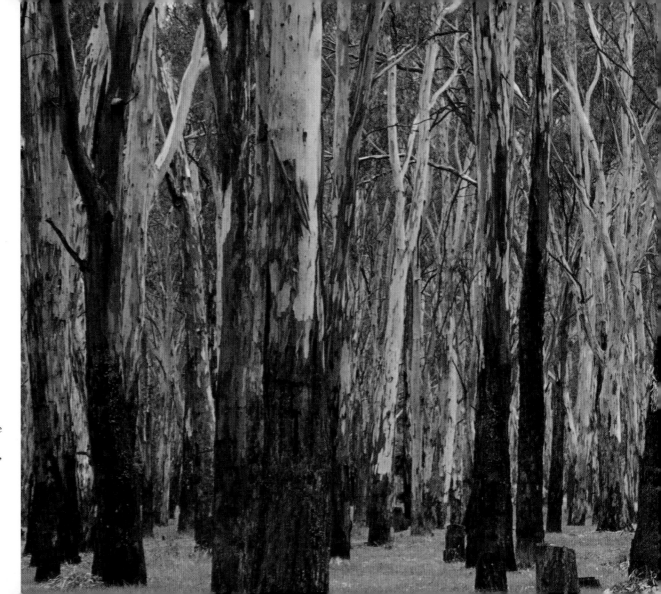

River red gums,
Murray River,
Yarrawonga, Vic.

BILL BACHMAN

Iconic eucalypts like
these can survive
periodic inundation,
growing best when
flooded annually
during winter.

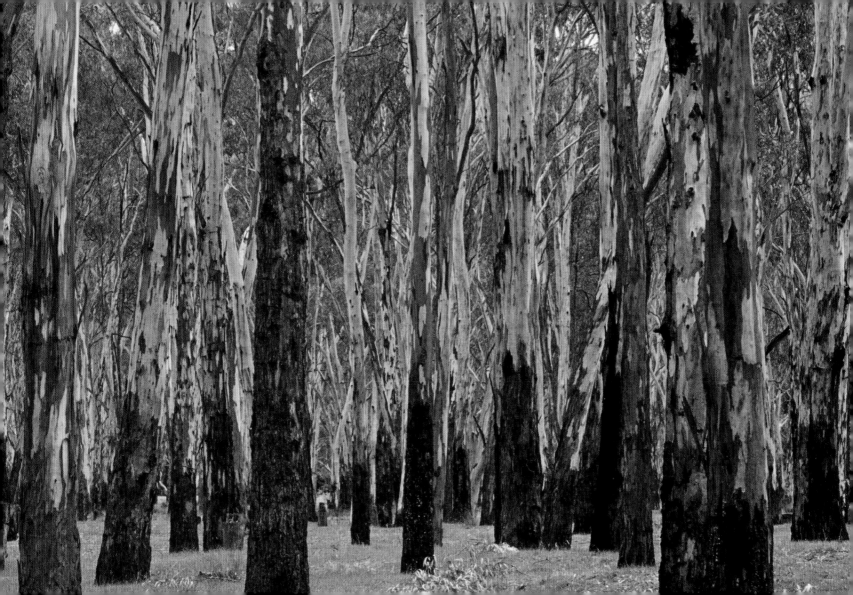

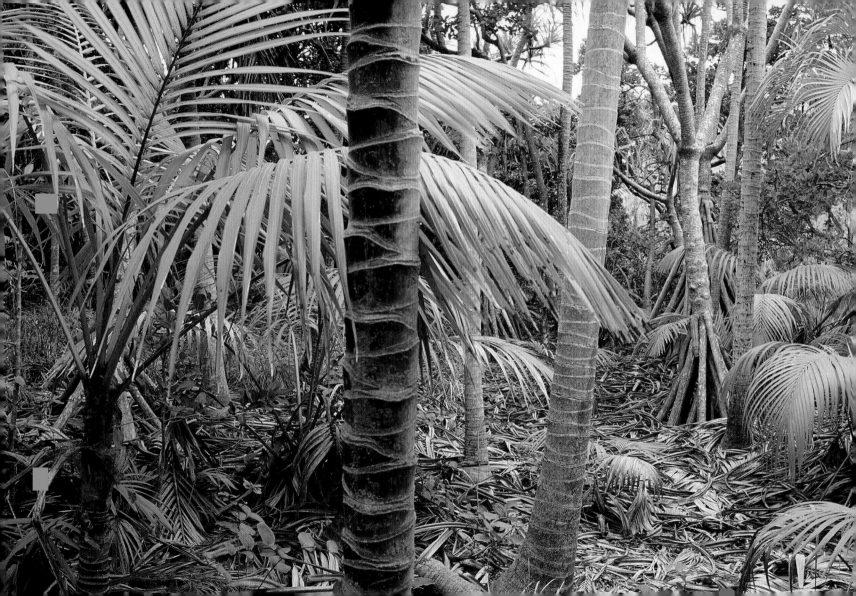

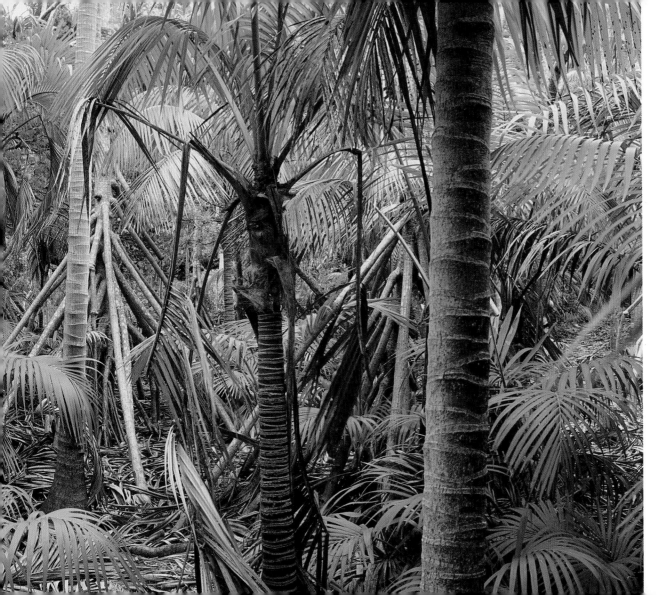

Kentia palm forest, Lord Howe Island, NSW.

GRAHAME MCCONNELL

These 15m-high palms give Lord Howe its distinctive appearance and have become one of the world's most popular indoor house plants.

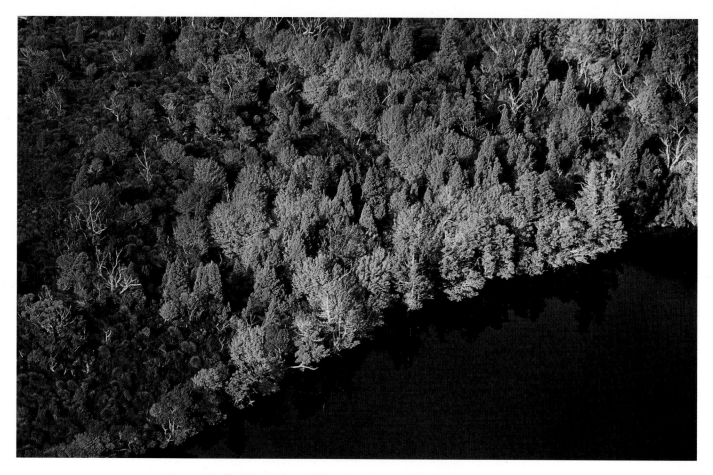

Fagus, Cradle Mountain—Lake St Clair National Park, Tas. JASON EDWARDS

Australia's only native cold-climate deciduous trees line the shores of Lake Hanson.
In autumn, the sun paints their 5—7mm leaves with ever more golden hues.

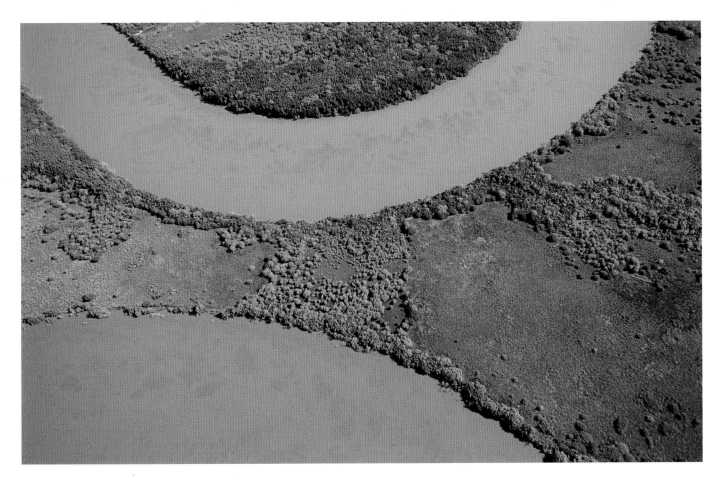

Adelaide River, NT. DAVID HANCOCK

The mighty Adelaide River winds its way towards the coast, laden with brown silt
that has been swept into it by wet-season waters from overflowing flood plains.

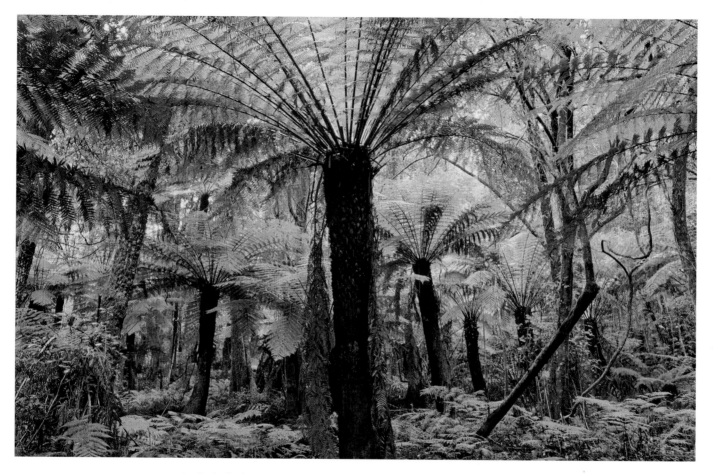

Cathedral of Ferns, Mount Wilson, Blue Mountains, NSW. DON FUCHS

An impressive remnant of Mount Wilson's original vegetation survives in this spectacular
stand of temperate rainforest with its giant tree ferns, sassafras and coachwood.

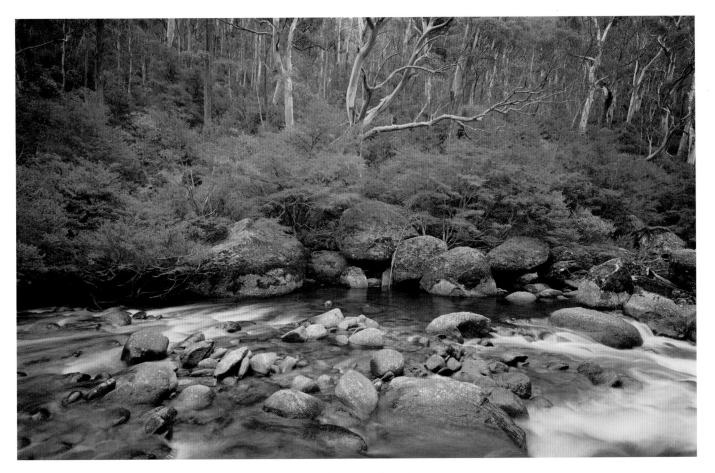

Thredbo River, Kosciuszko National Park, NSW. ROSS DUNSTAN

The river carves its way north-east towards Jindabyne along an ancient fault line
resulting from the uplifting of the Kosciuszko Massif 60 million years ago.

Australian GEOGRAPHIC

LANDSCAPES OF AUSTRALIA

PHOTOGRAPHS FROM THE AUSTRALIAN GEOGRAPHIC IMAGE COLLECTION

All the photographs featured in this book can be ordered as high quality photographic prints.
For details and prices, please visit **www.australiangeographicprints.com.au**

AUSTRALIAN GEOGRAPHIC EDITOR IN CHIEF: Chrissie Goldrick
BOOK DESIGN: Mike Rossi WRITERS: Quentin Chester, Chrissie Goldrick, Ken Eastwood
SUB-EDITOR: Josephine Sargent PROOFREADER: Nina Paine
PRODUCTION MANAGER: Victoria Jefferys PREPRESS: Klaus Müller

BAUER MEDIA CEO: David Goodchild
AUSTRALIAN GEOGRAPHIC PUBLISHER: Jo Runciman
PUBLISHER, SPECIALIST DIVISION: Cornelia Schulze

First printed in 2011; reprinted in 2015
Printed in China by Leo Paper Products

© Bauer Media 2015

Published by Bauer Media, 54–58 Park Street, Sydney, NSW 2000
Australian Geographic customer service 1300 555 176 (Australia only)
www.australiangeographic.com.au

AUTHOR: Chester, Quentin.
TITLE: Landscapes of Australia : images from the Australian Geographic image collection / Quentin Chester, Chrissie Goldrick.
ISBN: 9781742452258 (hbk.).
SUBJECTS: Australian Geographic Pty. Ltd.--Pictorial works. Landscape photography--Australia. Australia--Pictorial works.
OTHER AUTHORS/CONTRIBUTORS: Goldrick, Chrissie.
DEWEY NUMBER: 910.9

Other titles in the series Photographs from the Australian Geographic Image Collection:
Australia in Colour

FRONT COVER:
Whitehaven Beach, Whitsunday Island Group, Qld.
ANDREW GREGORY

Picture-perfect Whitehaven boasts 5km of pristine white silica-rich sand and is popular with day-trippers from nearby Hamilton Island.

TITLE PAGE:
Horseshoe Falls, Mt Field National Park, Tas.
BILL HATCHER

Pretty Horseshoe Falls, fed by alpine snowmelt collected in Neena Creek, flow all year-round in Tasmania's oldest national park, established in 1916.

BACK COVER:
Millstream Chichester National Park, WA.
NICK RAINS

Arid, flat tableland country dotted with spinifex grass in the George River region of the park contrasts with lush, green gorges further south.